www.ingramcontent.com/pod-product-compliance
Lightning Source LLC
Chambersburg PA
CBHW061149180526
45170CB00002B/694